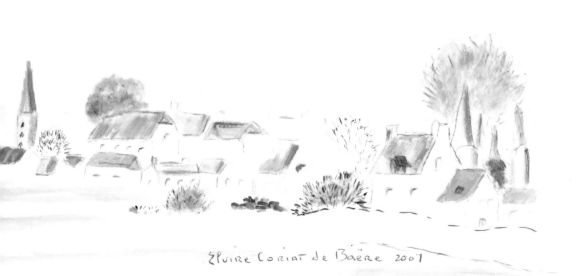

Elvire Coriat de Baëre 2007

Acclaim for *Realm of Silence*

"Realm of Silence *is like being blown by a stiff winter wind. You feel chilled afterward by a force you never saw coming. The paintings are a study in subtlety: they're stark without being simplistic, evocative without being maudlin. And they portray the unimaginable horror and death of the Holocaust without actually displaying any of it.*"

— Joe Eskenazi, Staff writer,
J. the Jewish news weekly of Northern California

"Realm of Silence *pairs painting and poetry to create a haunting, yet beautifully rendered narrative. Using monochromatic colors and gentle brush strokes, she has crafted a memorial to the victims of one of humanity's darkest hours with a tenderness not often seen in Holocaust art. It is because of art like that in* Realm of Silence *that we begin to go beyond seeing the photographs and knowing the facts to understanding some of what the Holocaust was about.*"

— Erin M. Blankenship,
Curator of Exhibitions and Collections, Florida Holocaust Museum

"*The beauty and subtlety of Elvire de Baëre's paintings and the poetry that accompanies them are both disturbing and uplifting. They are an awesome lesson for both children and adults, which is extremely important at this time when memory of history seems to be fading. They are an excellent teaching tool. They create the perfect mood for understanding the gravity and power of both cruelty and suffering, without exploiting the shocking images.*"

— Rabbi Emeritus Michael Barenbaum,
Congregation Rodef Sholom, San Rafael, California

REALM of SILENCE

Reflections on the Holocaust

Elvire Coriat de Baëre

LOST
COAST
PRESS

Realm of Silence
Reflections on the Holocaust
Copyright ©2008 by Elvire Coriat de Baëre

Cypress House
155 Cypress Street
Fort Bragg, CA 95437
(800) 773-7782
www.cypresshouse.com

Cover and book design by Michael Brechner
Cover artwork entitled "Dream" by Elvire Coriat de Baëre

Permissions
Poem on page 4, reprinted from *Hannah Senesh: Her Life and Diary, The First Complete Edition*, © 2004 by Eiten Senesh, David Senesh, and Ginsora Senesh. Permission granted by Jewish Lights Publishing, PO Box 237, Woodstock, VT 05091; **www.jewishlights.com.**

Library of Congress Cataloging-in-Publication Data

de Baëre, Elvire Coriat, date-
Realm of silence / Elvire Coriat de Baëre. -- 1st ed.
p. cm.
ISBN 978-1-882897-97-1 (casebound : alk. paper)
1. de Baëre, Elvire Coriat, date. 2. Holocaust, Jewish (1939-1945), in art. I. Title.
ND237.B2215A4 2008
759.13--dc22 2007051081

Printed in China
2 4 6 8 9 7 5 3 1

Dedication

I dedicate this work to those who perished during the Holocaust, leaving no trace but memories that will shine forever— and to honor the indescribable suffering of the survivors.

Contents

List of Illustrations

Foreword

By Stephen M. Goldman,
Former Museum Director, Florida Holocaust Museum

Art and poetry, poetry and art. Two sounds of the same voice, two songs of the same tune.

In *Realm of Silence*, Elvire Coriat de Baëre has taken her small and exquisite paintings and illustrated them with "miniature" poetry of high order. Her French spirit, that cultural romanticism typical of her French classical roots with the artistic essence, brings a new expression to the heretofore silent and unheard.

In her poetry, Ms. de Baëre has brought song and words together; not the way we think of music; not the notes and words of a popular tune, but poignant verse accompanied by heartstrings exploring the emotional depths of the tortured souls of six million dead.

As you plumb the inner workings of the simple yet complex little collection, do not despair, do not fret, for here is light, revealing a special truth. In *Realm of Silence*, de Baëre's paintings depart from her usual romantic themes; here she eschews the bright colors of French modern art, the stylization of French Impressionism. Almost devoid of color, nearly monochromatic, the oil paintings are derivative of those images with which we are so familiar. Like many post-Holocaust artists, she has used these historic images and "historiographed" them. The historiographer makes history accessible on a different plane, one that speaks not to the intellect, but to the spirit.

Holocaust art, including post-Holocaust work, must be seen in a special light. The event of the Holocaust is unique, not in its insidiousness, nor in its intent to murder an entire people, but in the audacity of the perpetrators in the extent of documentation left for us to contemplate and study. Of course Ms. de Baëre's paintings are derivative; virtually all images of the Holocaust are derivative.

Many disparage the post-Holocaust images of artists and poets. Critics abound. Yet here is a truth revealed to many who could not otherwise see truth. A voice that

speaks not to our ears, but to the childlike innocence of those who are able to suspend disbelief.

Look. Many denigrate the false prophet of the non-survivor, "he who did not witness." But we can see with the eyes of the seer, the visionary who would show images of a past neither of us experienced. See.

Listen. Elvire Coriat de Baëre sees; she speaks. She sees what we should see; she speaks what we should hear. Enough of the sound of silence, she says; enough of the darkness of closed eyes. Ms. de Baëre is a contemporary artist of merit and a poet of our time. She is brave enough to attempt to come to grips with the horror of the Holocaust and share that experience. Many cannot bear to share the images and words; it remains for artists and poets with guts to see and speak for us, to us. Hear.

Internalize. Much of what we have seen and heard about the Holocaust comes from history books, novels, films. But much of what we understand about the Holocaust comes from the brushes and chisels of artists, the pen of the poet.

Look, listen, here is a key to the door of understanding, to a hall of emotion. Perhaps then you can exit to a world of coexistence. Understand.

Realm of Silence is a special collection, a very special book.

Artist's Statement

Painting is not exclusively visual; it is an act of the soul. It is the means by which I express passion, emotion, and sensitivity for the subject I portray.

My love for painting has been lifelong, first in its observation and study, then in my own expression, which celebrates the magical beauty of nature, its power and serenity. My art depicts mostly landscapes, seascapes, still life, flowers, and children.

I have benefited from academic training in French modern art. My work shows the influence of the Old Masters and French Impressionism.

The nine-painting series "Realm of Silence" is a response to my thoughts on some of the most powerful images of the twentieth century. I have excluded color to evoke a sense of loss and despair.

In reading and reflecting on World War II, images of human atrocities filled my soul, mind, and heart with an undeniable pain. Never in the history of mankind has such dehumanization happened. Through my painting and poetry, I feel an urgency to hold sacred and perpetuate the memory of those who perished.

Through artistic expression I appeal to the viewer to reflect upon the moral and spiritual questions raised by the Holocaust. Awareness of the past may prevent recurrence and promote human dignity and social justice for generations to come.

Hannah Senesh

Hannah Senesh was born in Budapest, Hungary, in 1921, became a partisan resistance fighter, and was arrested, tortured, and executed in 1944. I discovered the following poem after I had completed the paintings and the poetry for this book, and found that it harmonized with my intent to perpetuate the memory of those who live only in our hearts.

There are stars whose radiance is
Visible on earth
Though they have
Long been extinct.

There are people whose brilliance
Continues to light the world
Though they are no
Longer among the living.
These lights are particularly
Bright when the night is dark
They light the way for
Humankind.

Hannah Senesh

Acknowledgments

Many people have shared with me their love and support during the creation of this small book.

I would like to express my heartfelt gratitude to Chester Arnold, my teacher, for his advice and encouragement through this emotional journey, and for writing *Redemption Through Art* for this book.

Much affection to Professor Isaac Jack Lévy who has been an inspiration and friend during all these years.

I am honored and thankful to Professor Stephen Feinstein for believing in my work and for his wonderful comments.

My appreciation to Joe Eskenazi for his generous review.

I am grateful to Erin Blankenship for her comments.

My deep appreciation to Stephen Goldman for his moving foreword.

My gratitude to Bob Gordon for his friendship and legal advice.

Thanks to Dan Haagens for his computer expertise.

Many thanks to Avi Love and Larry Boggs for their assistance in the preparation of the manuscript and for their support.

Much affection to my good friends and family who patiently listened to my dream throughout this endeavor.

I am grateful to my daughter, Rachel, for her editing help with my poetry.

And last but not least, special thanks to my husband, Jean, who provided a generous climate in which to create my dream.

In Memoriam

Professor Stephen Feinstein was deeply committed to promoting dignity and rooting out the causes of genocide in the world. He was a voice for human rights. His premature death is a terrible loss, and he will be deeply missed.

Introduction

Realm of Silence: Redemption Through Art

It may seem an insurmountable task to see any beauty in the darkness of the twentieth century's gravest hours—and indeed, when one reads the documentation of the devastation and squalor from the trenches at Verdun and other killing fields of the First World War to the ovens of Auschwitz in the Second World War, it is hard not to be sickened by the merciless momentum of death inflicted by man against man. Film has captured the visual realities of those and other periods of disaster with brutal and haunting directness. It has been the singular achievement of writers and visual artists who have lived amidst those hours of chaos to transform that horror, to provide it with a human perspective that can only be received as a testament to caring.

Throughout history, art has embraced the world's experience through its transformative power. Both good and ill are shaped by individual sensitivities and talents into a creative legacy that peacefully, eternally beckons our reflection and celebration. In my own experience as an artist and teacher, I have engaged in many struggles to define the potential range of what we allow art to explore, and it is through that struggle to create meaning that I encountered the evolving work that became both poem and painting in this book. Elvire Coriat de Baëre at first did not seem a candidate to tackle one of history's darkest hours. With a gentle spirit and painting style at once sunny and light, she had been known for her evocation of joyous life and landscapes.

When she approached me with her ideas and research for a single image of the Warsaw Ghetto (which became "Terror in Its Wake," the second painting in the series), I was more than a little surprised. But I was sobered by her earnestness and her lifelong compassion for the millions of victims of the Holocaust who lie shrouded in a veil of mystery and impossible reflection. How could a painting, after all, begin to encompass the magnitude of that horror and loss? That single painting, however, became the door through which the depth of her emotions would be realized, and became the poignant and now-renowned series of paintings and poems that follow.

In our time, the purpose and meaning of art have led artists everywhere to look deeper and more thoroughly into experience in the world, as the parameters of what art can be are perpetually reinvented, in a very personal way, with a process that is as poetic in its pictures as it is painterly in its poems.

Elvire Coriat de Baëre has created a series of reflections that the eye and mind may engage with gently, reflections that honor life and condemn barbarity in the most tender and human of ways. One may find in these pages a recognition of the darkest realities of the Second World War, yet simultaneously an affirmation of spirit and compassion, an art dedicated to the redemption of human grace and dignity.

Chester Arnold
Artist and Professor of Art,
College of Marin, Kentfield, California

REALM OF SILENCE

Downward the Light Wanders

Anguish-laden clouds
Obscure the sky of former days
The unknown approaches.

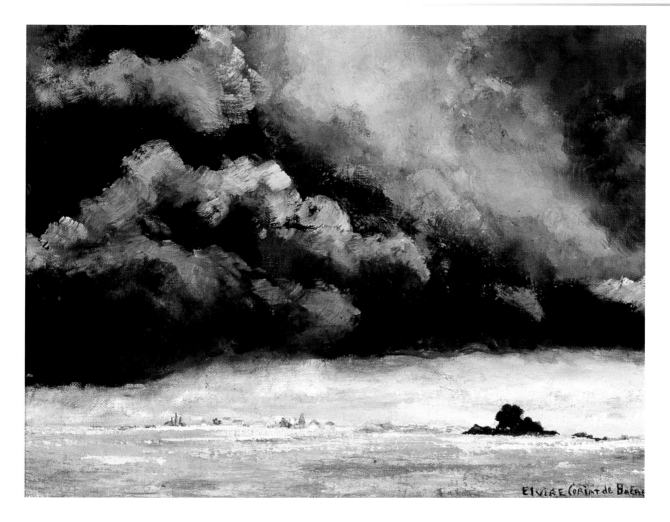

Terror in Its Wake

1940
Men, women, children, thousands
Taken from their homes.
The Warsaw ghetto sealed
On the 16th of November,
For 470,000
Hunger and disease,
Humiliation and terror.

1942
Deportation begins,
Anguish
Desire to resist is born.
April 19, 1943
The 20,000 remaining
Stage an uprising.
The SS burn house after house.
A sea of flames and suffocating smoke laps the city.
The struggle is heroic and tragic.

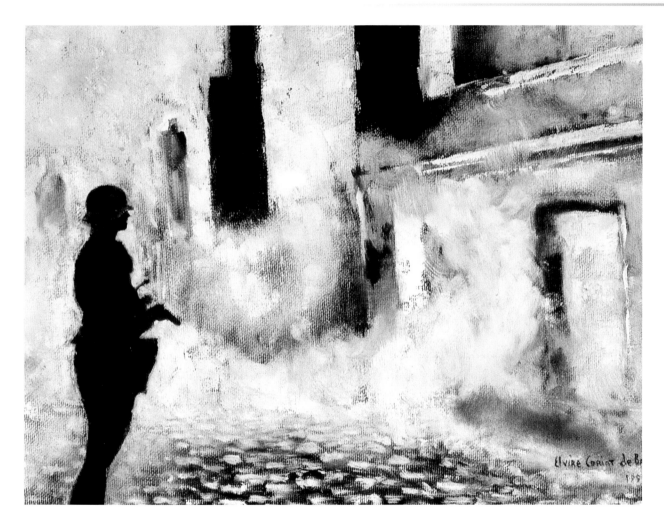

Is This Your Last Walk?

Forced to wear the yellow star
Barred from all professions
Land and houses confiscated
Bewildered bodies
Carry all they have left.

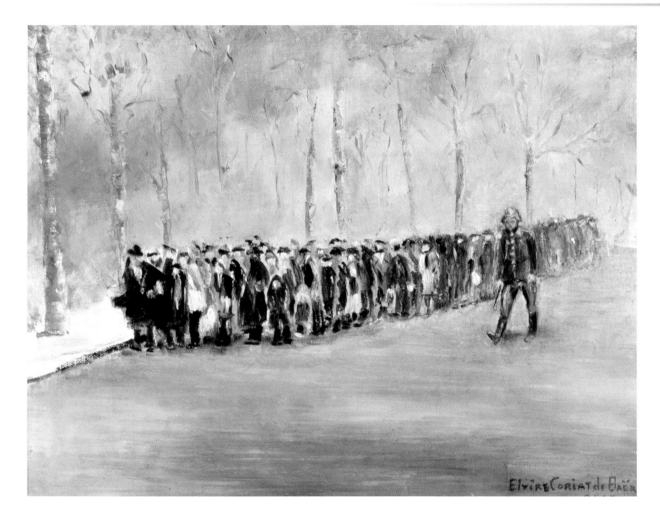

Death's Journey

Uniformed guards herd them
Into sealed wagons.
The journey lasts
Days and nights
To an unknown destination.
Thirst and starvation.
Stench of death.
Suffocating heat.
Freezing torment.
Persistent rattling of trains,
Whistles howling.
A sudden halt…

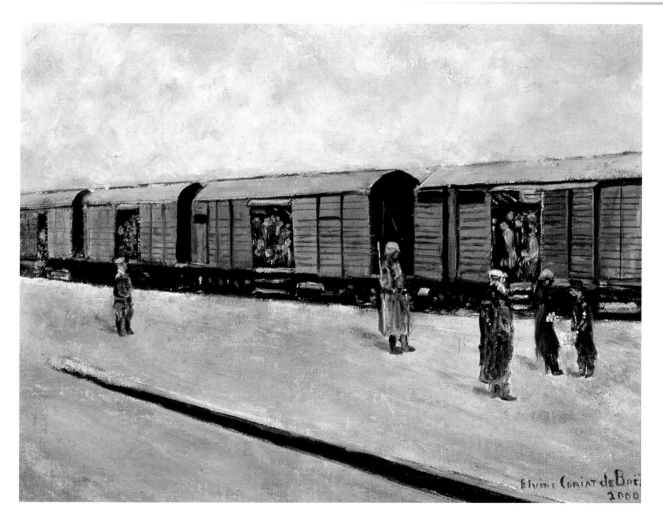

Habitation of Death

Bolted doors opened,
Auschwitz.
The lineup and the sorting.
To the right,
Fit to work,
Tattooed with numbers,
Beaten and starved.
To the left,
Unfit to work,
Murdered.

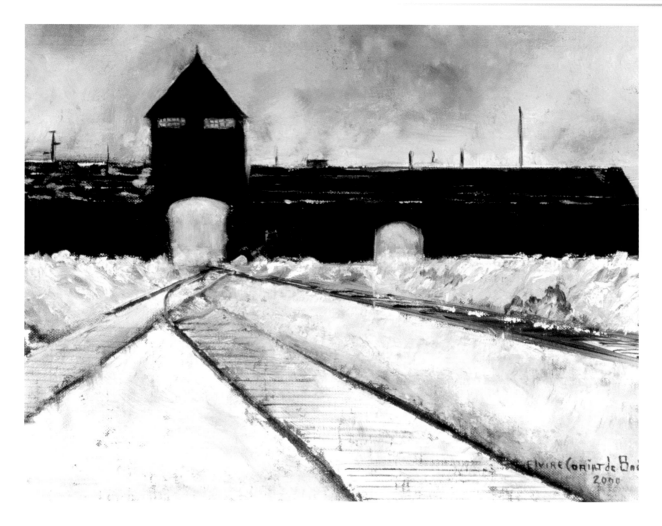

Elvire Corint de Bri
2000

Frozen Nightmare

Triple electrified barbed wire fences
In the bleakness of winter
Grieving caged souls
Cannot escape.

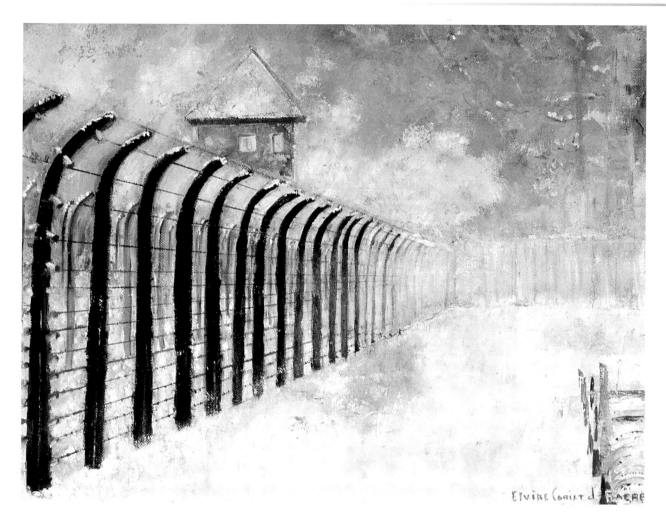

Elvire Coriat d...

Silenced Voices

Volcano of screaming shoes
Made of dead leather
Torn cloth
The flesh, the souls
That filled them
Children, brides,
Tailors, old women, poets…

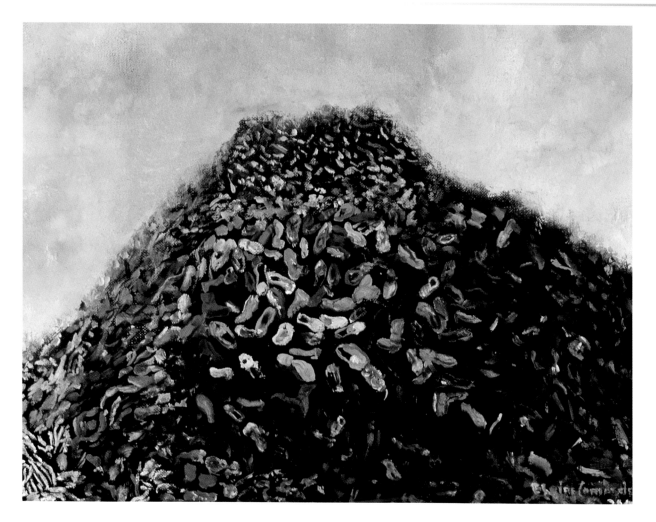

Who Is Watching?

The innocents stand naked.
Outside waterless taps turn on
The taps hiss Zyklon B gas
Who looked through the peephole
To see how fast they died?

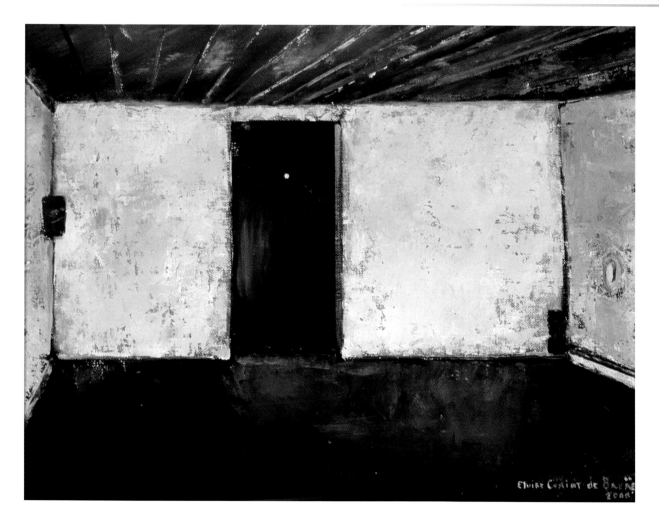

Shine Forever

From the ashes of extinction
We illuminate the souls,
Pass on the light
To future generations.

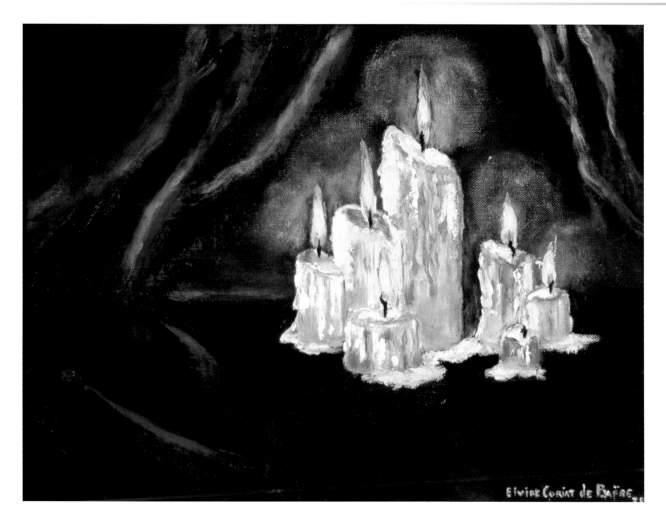

About the Artist

Elvire Coriat de Baëre was born in Casablanca, Morocco. She immigrated to the United States in 1956 and currently lives in California with her husband, near her two children and three grandchildren. She started painting in her thirties and received her formal training in the Old Masters technique with the late Troy Ruddick. Ms. de Baëre holds degrees in art and Spanish as well as a teaching credential in French, and has studied at the École des Beaux Arts in Paris. Some of her more recent work explores egg tempera medium with oil glazes, gold leafing, frescoes, and watercolors, but she primarily paints with oil on linen.

Numerous exhibitions of Ms. de Baëre's work have been held in Paris, Montlhery, France, and in the San Francisco Bay Area. Her paintings have appeared in several publications, including *Maison Française* and the *Artelano Design Catalogue* in Paris. In November 2000 her work was discussed in a feature article in *J. the Jewish news weekly of Northern California*. In 2003, she was nominated for the Beryl H. Buck Award for Achievement. Ms. de Baëre is one of twelve artists featured in the forthcoming book *Sephardic Art of the Holocaust* by Dr. Isaac Jack Lévy, author of the noted work *And the World Stood Silent: Sephardic Poetry of the Holocaust.*

In her current "Realm of Silence" series, executed in oil on linen, Ms. de Baëre reaches monochromatic tonalities unprecedented in her art. This series has come to the attention of two Holocaust museums in the United States. Slides, photographs, and documentation of the series are available at the Artists' Registry at the United States Holocaust Memorial Museum in Washington, DC. In 2002, Elvire Coriat de Baëre donated the series (including the nine oil paintings and the nine poems) to the Florida Holocaust Museum in St. Petersburg, Florida, for their permanent collection. The series is a traveling exhibit.

Ms. de Baëre is currently working on a series of paintings in oil that portray multicultural women in period scenes and landscapes.

Guest Book

Comments made at various exhibits of the paintings and poetry reproduced in this book

"What a captivating, poignant and moving explanation of your creation. I will carry your words and visions with us."
— Rosemary Lévy Zimwatt

"You bring the truth, and when the truth is told you allow people to embrace the pain, and by having this experience people are able to open their hearts to love."
— Donna Lifrah

"This series is very impressive and emotionally evocative. It especially resonated with me because I lost a lot of family members in Hungary."
— Olga Thein

"Your paintings match perfectly the poetry that inspired them. Beautiful and deeply moving."
— Donna Terdiman

"Thank you for your thoughtful achievement in finding beauty even in the darkest hours of history."
— Chester Arnold, Artist and Professor of Art

"These are amazing, poignant, powerful, unforgettable."
— Kristie Garneau

"I was touched deeply. You create a safe place for the soul to experience. And explore."
— Melanie Duarte

"Thank you from first, second, third-generation survivors."
— Leah Baars and Alan Samuels

"Falkirk Cultural Center was honored to exhibit Realm of Silence by Elvire Coriat de Baëre. With its striking yet subtle poetic images, the work spoke volumes about the depth and gravity of this tragedy. Our audience was greatly moved by this work, which echoed powerfully in our galleries."
— Beth Goldberg, Curator of Exhibits, Falkirk Cultural Center

Guest Book

"Elvire, your poetry serves as the lyrics to your haunting and soul-stirring paintings of the Holocaust. I could not only see, but hear and feel the chill of the horrors that were before me—simple yet powerful in expression. More than a memorial, your work is an illumination of the tenacity we all must have to work against hatred and intolerance."
— Jeannette Longtin

"The paintings are breathtaking."
— Lisa Yanover

"Powerful in a quiet, subtle way. Superb in you message."
— Yvonne Walter

"I was especially moved by those eyes watching the killing. It made my hair stand on end."
— Virdell Hickman

"I came to say goodbye to my father."
— Anonymous

"Your paintings are a beautiful memorial to people who will need always to be remembered."
— Gary and Ruth Friedman

"My warmest congratulations on your achievement, not only the paintings, but the meaningful poetry."
— Barbara Cummings

"A superb, powerful experience. You captured so much in each painting to reach our souls and spirit."
— Barbara Schechner

"Thank you for the pictorial journey from the light of Europe to the clouds of impending doom—then to the light in memory of all those who suffered and died."
— Joan Blanchard

"Yitgadal v' yitkadash—They say, 'even G-d was horrified.' Judaism is still forming a response to what has only recently been called the Holocaust. Your work is very important to this response. Words cannot express what happened. Perhaps pictures can."
— Jongon

"Your soul and spirit come through so beautifully in your artwork depicting the Holocaust. It is a gift from God for all the world to see."
— Cantor David Margules